The Yorkshire Stridings

Photographs by Ian Beesley
Poems by Ian McMillan

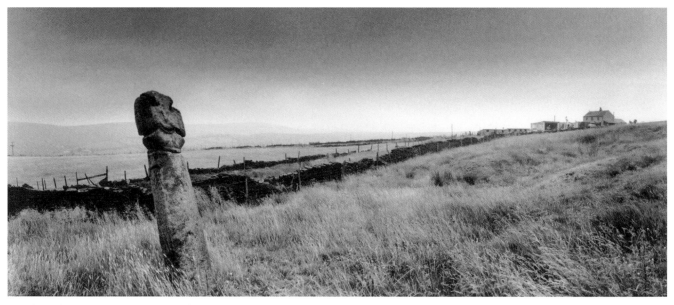

Medieval stone rose cross marking the boundary between Yorkshire & Lancashire.

Yorkshire: historic county of Northern England and the largest in the UK.

Ridings: The ancient county of Yorkshire had three ridings, North, West and South

Stridings: to walk with long regular or measured paces.

THE AMBITION OF THE YORKSHIRE STRIDER

To stride in all Yorkshire weathers.

To stride to Yorkshire places unstridden by me or others.

To place one foot in front of the other in the Yorkshire way.

To nod minutely to my fellow-striders, catching their eye like a cricketer might catch a high, high ball: casually, with skill and love.

To stride rather than ambling.

To listen intently to the birds singing in Yorkshire dialect: Aye, Aye, Aye.

To stride through Yorkshire towns and villages as though they are living maps of themselves.

To stride across Yorkshire moors and beaches as though you are in a film.

To stride rather than strolling.

To notice each Yorkshire cloud as though it is the first Yorkshire cloud or the last Yorkshire cloud.

To stride home knowing more about Yorkshire and the world and yourself than you did when you strode out.

To notice as much as you can to keep in a memory bank for the times you are stuck on a failed train.

To stride rather than loping.

To always have striding ambitions: there will always be more Yorkshire. Always.

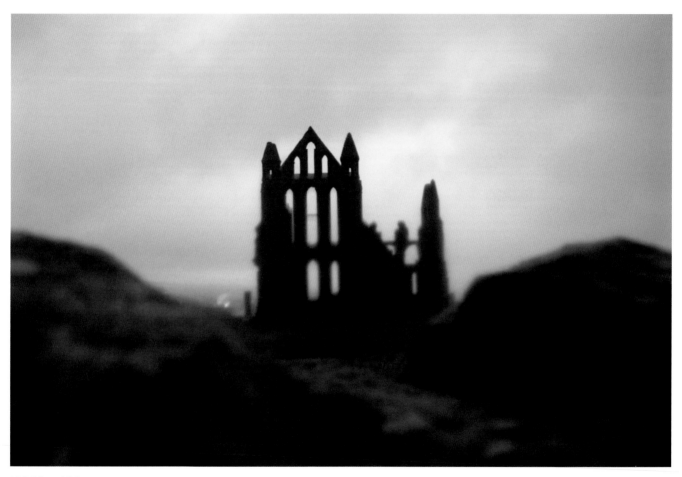

Whitby Abbey

STRIDING

Late night striding is the best, as one day curves into the next with an audible click.

The moors are more mysterious at this time; they seem to hold more secrets, more stories, more narratives that begin and end in Yorkshire dark.

Time itself seems to stand still like someone on the top of the moor stands still to take in the stars.

Then Time turns and walks forward, slowly as a clock.

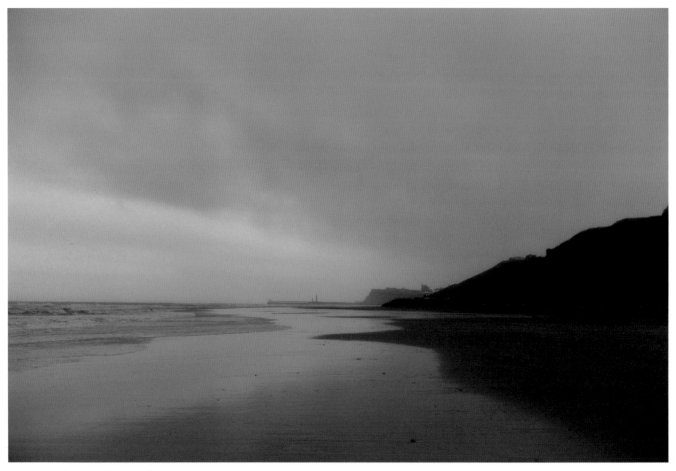

Sandsend towards Whitby

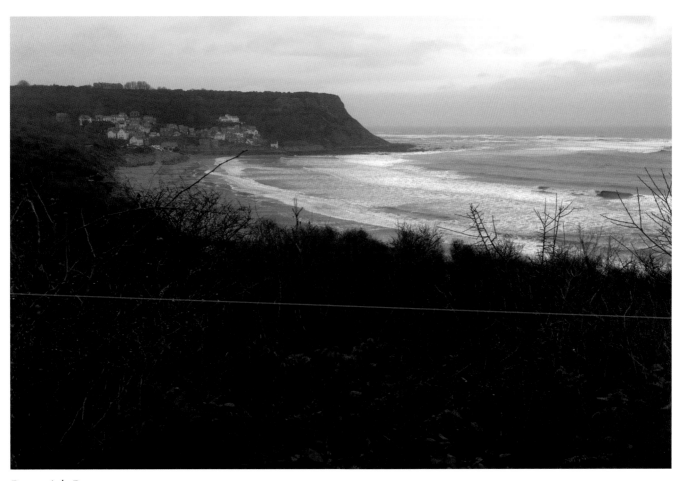

Runswick Bay

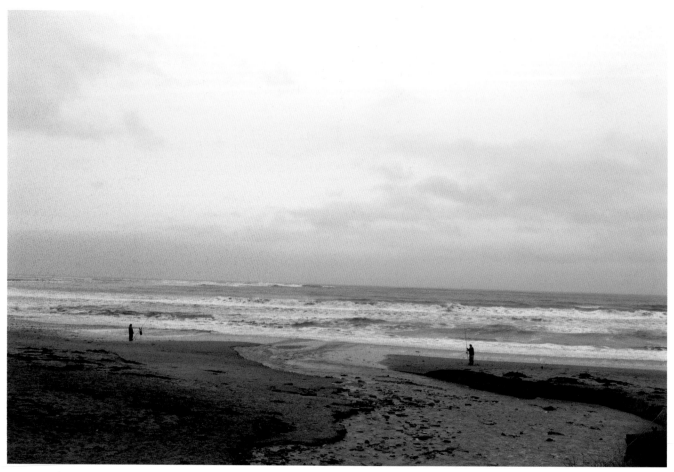

Runswick Bay

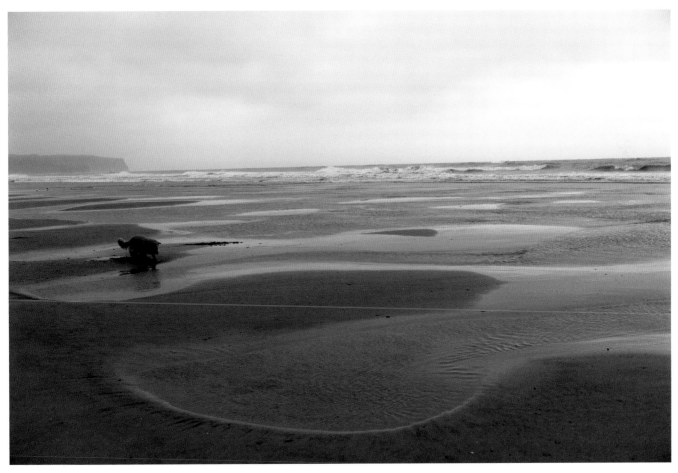

Sandsend

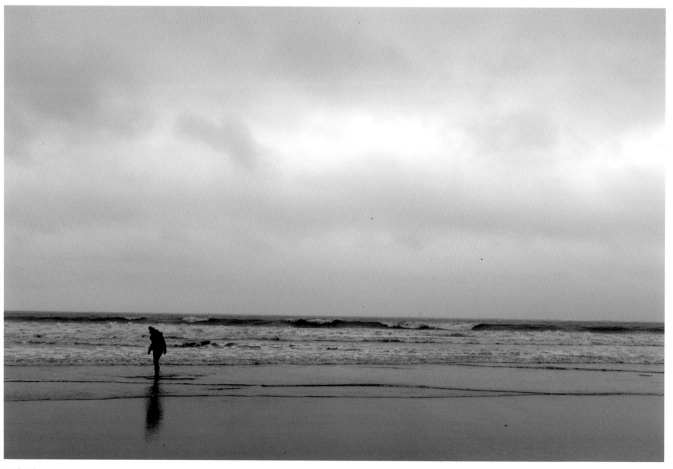

Whitby

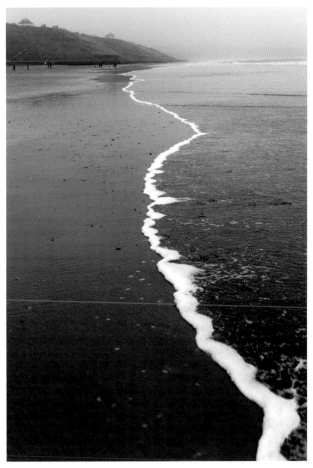

Whitby

STRIDING

Stand at the top of the slope and listen beyond your breathing, beyond the cars on the distant road, beyond the aeroplane behind the clouds.

Listen beyond the breeze giving narrative to the moving leaves in the tiny wood and beyond the cows making themselves heard in a field bordered by fences and a sense of yesterday.

Listen beyond the shouts of children far below by ice-cream van.
Listen beyond them all and you will hear the Yorkshire light.

Then turn and stride.

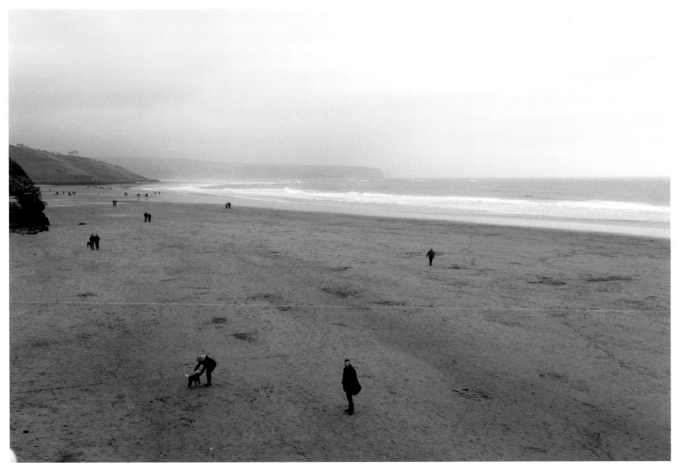

Whitby

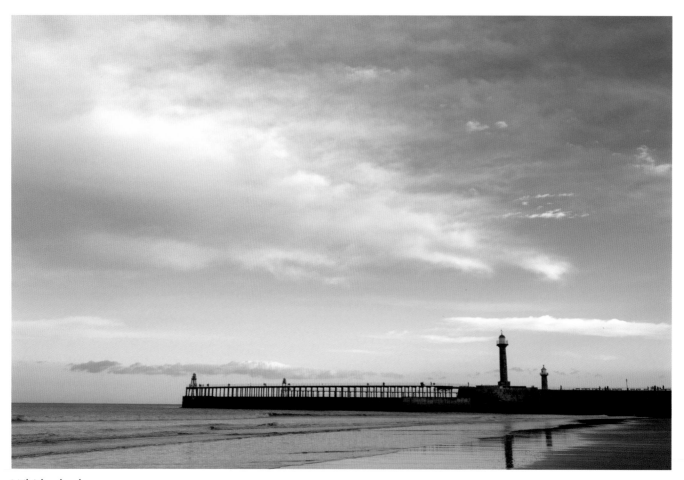

Whitby harbour

STRIDING

Afternoon striding is the best. The sun lowers itself in the sky, as though it is leaning in, as though it wants to tell you something about time. The streets are busy as the schools empty and someone runs up the hill and someone dawdles and someone opens a car door and shouts something welcoming in an accent that has hardly changed for a hundred years; man walking past the school to fight in First World War would have understood it perfectly, until the guns sent them deaf.

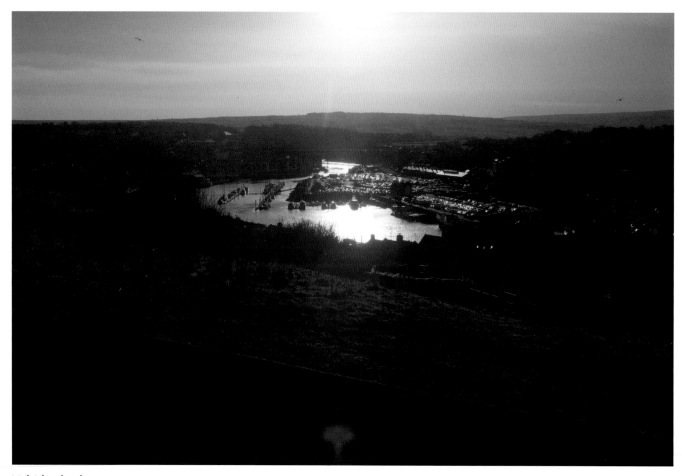

Whitby harbour

Striding along Magnetic North
across Ilkley Moor

Since early times European navigators believed that compass needles were attracted either to a "magnetic mountain" or "magnetic island" somewhere in the far north or to the Pole Star.

The magnetic field in a MRI scanner is aligned to Magnetic North and so to the Pole Star.

Both the scanner and magnetic north are symbolic of navigation and journeys, one in the literal geographical sense and the other in a metaphorical sense as in a journey through the body navigating tissues and organs.

This series of images represents a walk towards Magnetic North; it references time, the unseen and the circular shape of the MRI scanner.

All images were taken facing Magnetic North along an imaginary line starting from the MRI scanning unit at Bradford Royal Infirmary and traveling across the Yorkshire countryside.

The first part of this journey took me over Ilkley Moor and sites there included an ancient stone circle, a number of cup and ring marked stones, the Doubler stones allotment and an abandoned millstone quarry.

(It is believed that the cups on cup and ring marked rocks may have been cut for medicinal purposes, water collected in the cups would dissolve the salts from the rock and these solutions were believed to have healing properties).

Ian Beesley

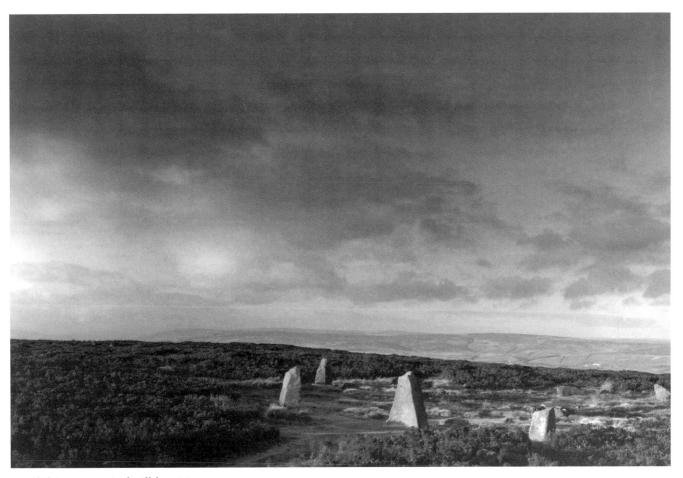

Neolithic stone circle Ilkley Moor

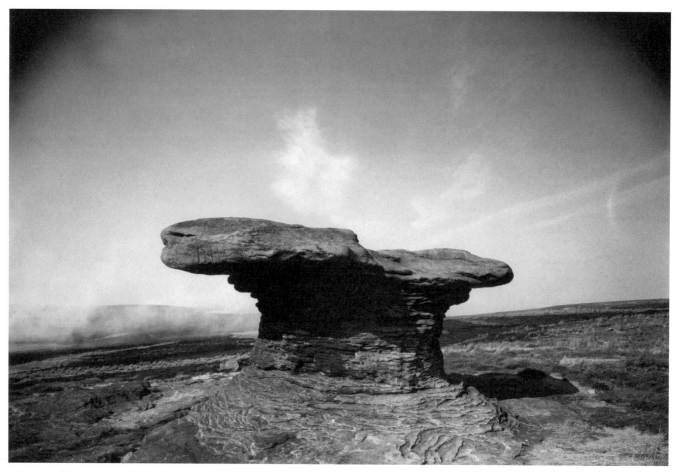

The Doubler stone Ilkley Moor

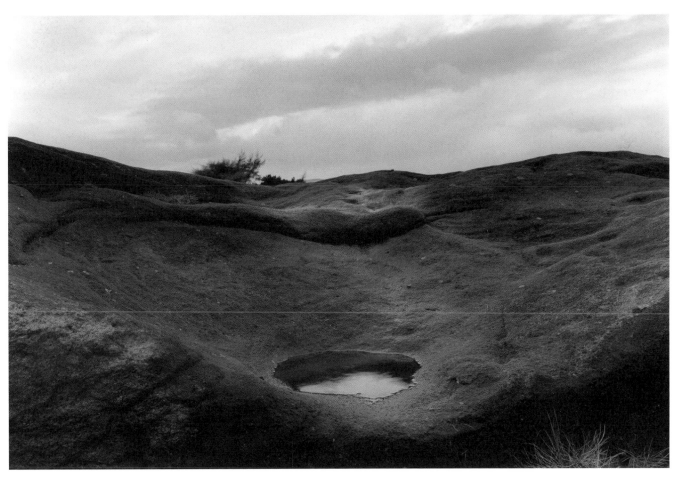

Cup and ring stone Ilkley Moor

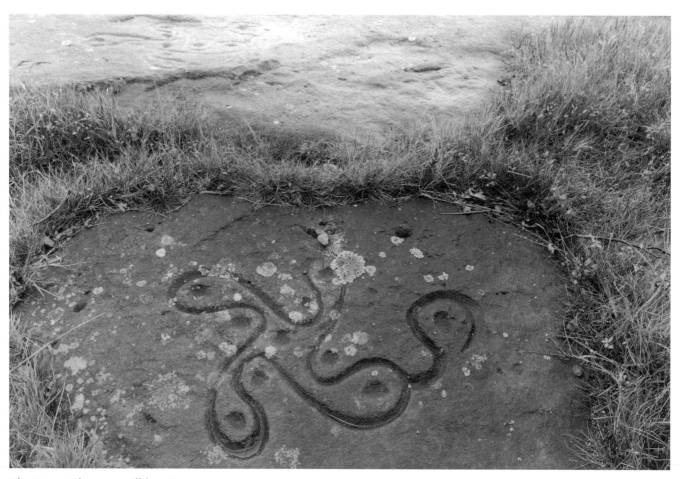

The Swazitika stone Ilkley Moor

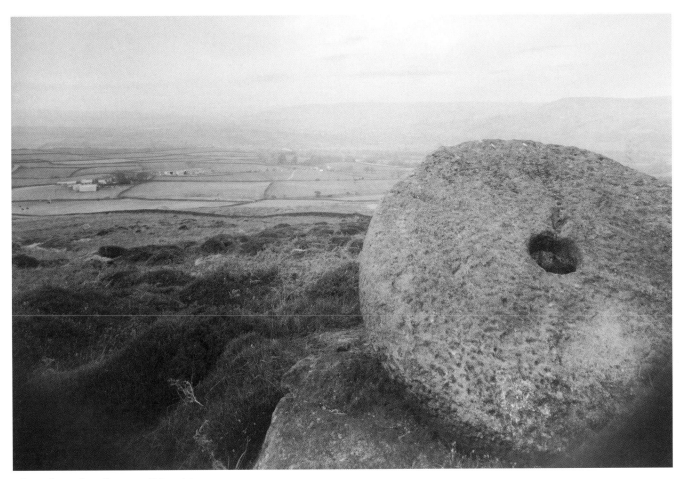

Abandoned millstone Ilkley Moor

MAGNETIC NORTH

My teacup handle points to the window,
My hair seems to lean to the vast outdoors,
The pen on my desk spins, and then stops.
I could walk from this place in a long straight line
Through fields, over moors, by the walls that stretch
And snake overland to the top of the map:
Magnetic North is calling me home.

Striding the limestone pavements

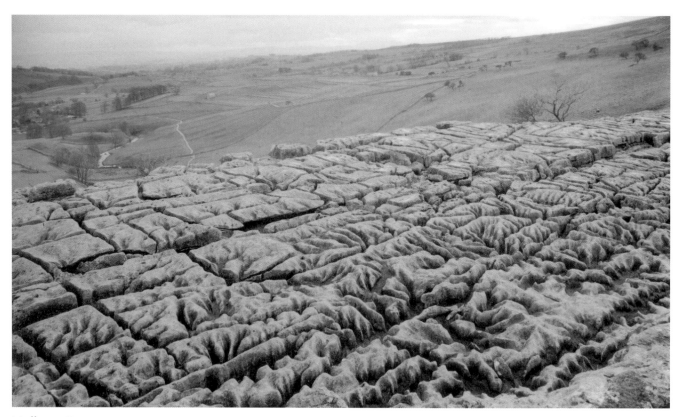

Malham Cove

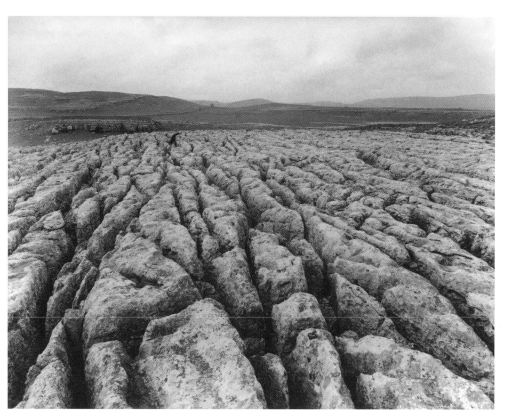

Limestone pavement Malham

LIMESTONE

The earth
Thinks
Wrinkles its brow.

Furrows
Deep in thought.
Trying

To remember something,
Anything,
About the day before
yesterday.

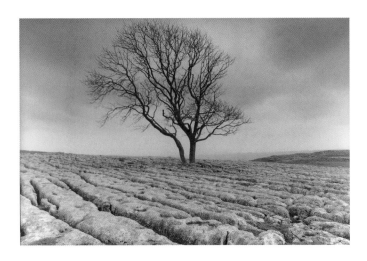

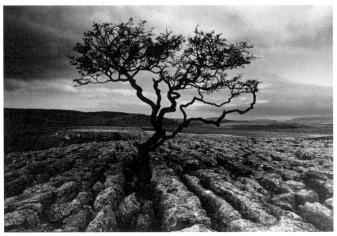

THE LIMESTONE TREE

From a distance, anyway.
A tree made of stone
Like a statue to the seasons

Roots in the limestone,
Branches in the air,
Pointing to the grey

Limestone sky.
From a distance, anyway
You look the branches

Point in one direction,
One point of the compass:
Limestone.

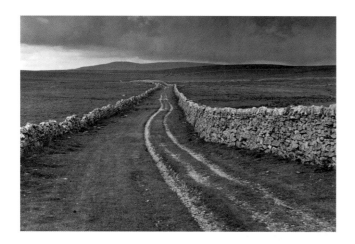

LIMESTONE AS STORYTELLER

Walls line the path
Like narrative devices;
Here, a mystery:
The missing stone.
Here, a twist:
The half-open gate.
Here, a moment
To stand on reflect
Before the tale
Moves on.
Here, a folk-memory
Of backbroken craftsmen
Placing stone upon stone
To an ending
The wind will howl through.

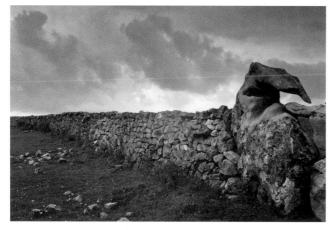

The limestone walls of Mastilles Lane Kilnsey

Striding in search of the white mountain hare

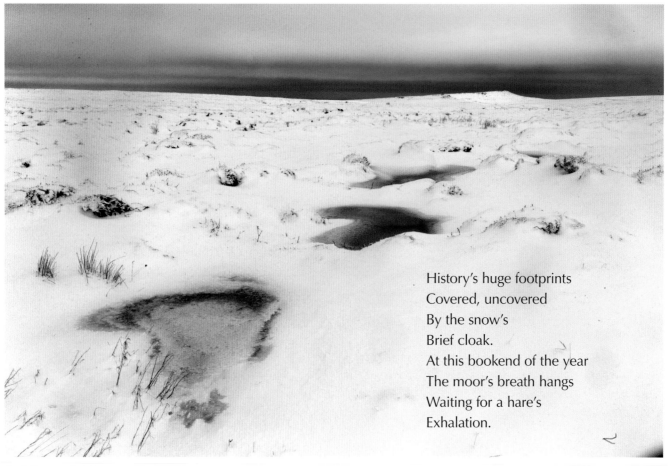

History's huge footprints
Covered, uncovered
By the snow's
Brief cloak.
At this bookend of the year
The moor's breath hangs
Waiting for a hare's
Exhalation.

Saddleworth Moor

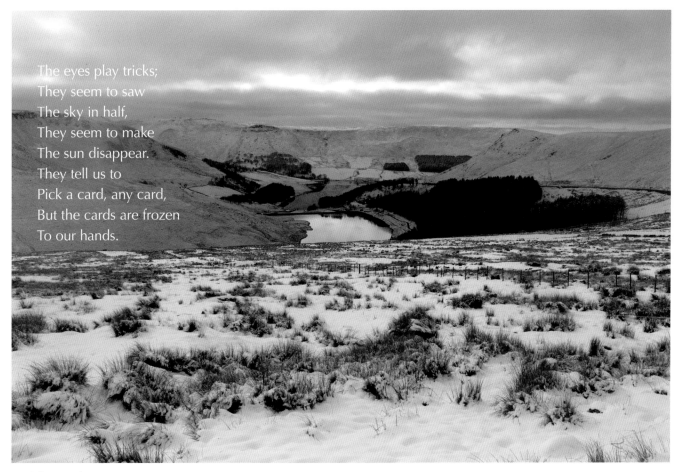

The eyes play tricks;
They seem to saw
The sky in half,
They seem to make
The sun disappear.
They tell us to
Pick a card, any card,
But the cards are frozen
To our hands.

Saddleworth Moor

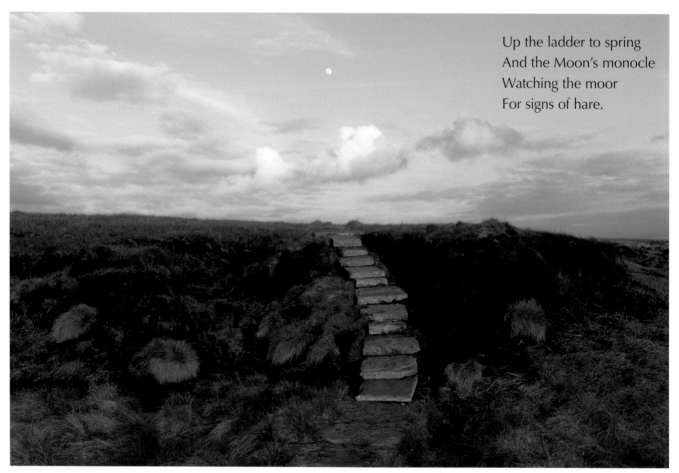

Up the ladder to spring
And the Moon's monocle
Watching the moor
For signs of hare.

Saddleworth Moor

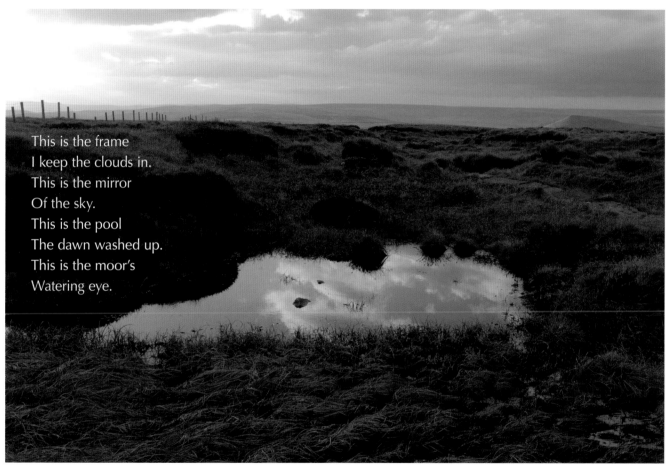

This is the frame
I keep the clouds in.
This is the mirror
Of the sky.
This is the pool
The dawn washed up.
This is the moor's
Watering eye.

Saddleworth Moor

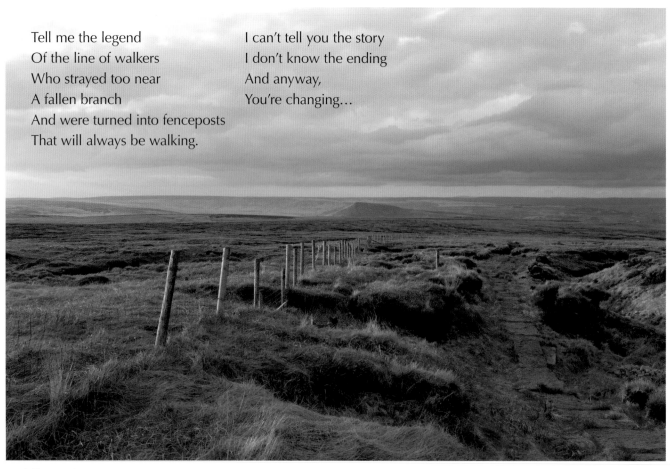

Tell me the legend
Of the line of walkers
Who strayed too near
A fallen branch
And were turned into fenceposts
That will always be walking.

I can't tell you the story
I don't know the ending
And anyway,
You're changing…

Saddleworth Moor

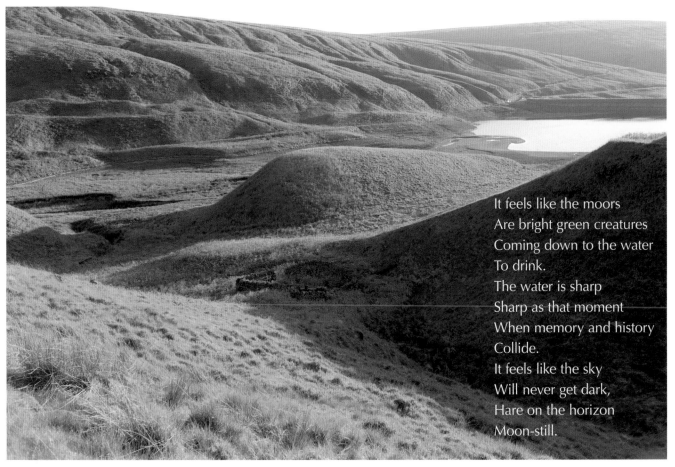

It feels like the moors
Are bright green creatures
Coming down to the water
To drink.
The water is sharp
Sharp as that moment
When memory and history
Collide.
It feels like the sky
Will never get dark,
Hare on the horizon
Moon-still.

Saddleworth Moor

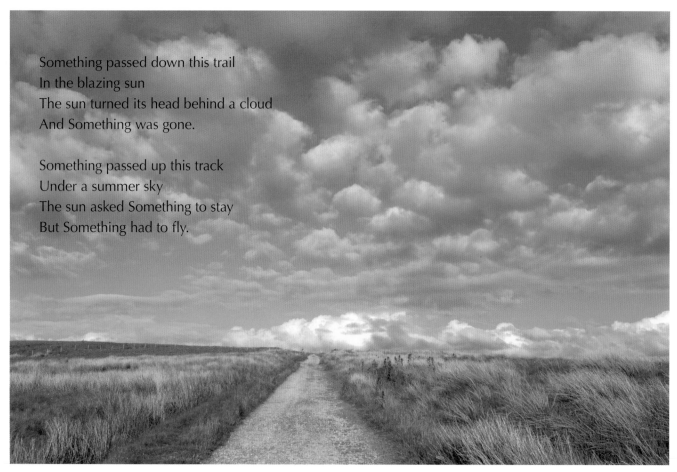

Something passed down this trail
In the blazing sun
The sun turned its head behind a cloud
And Something was gone.

Something passed up this track
Under a summer sky
The sun asked Something to stay
But Something had to fly.

Saddleworth Moor

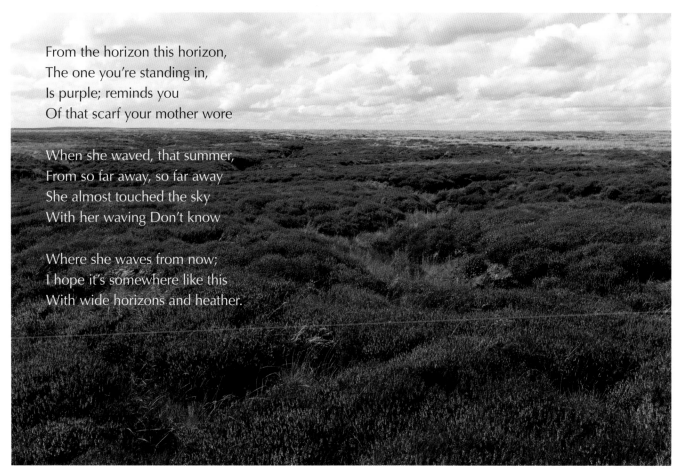

From the horizon this horizon,
The one you're standing in,
Is purple; reminds you
Of that scarf your mother wore

When she waved, that summer,
From so far away, so far away
She almost touched the sky
With her waving Don't know

Where she waves from now;
I hope it's somewhere like this
With wide horizons and heather.

Saddleworth Moor

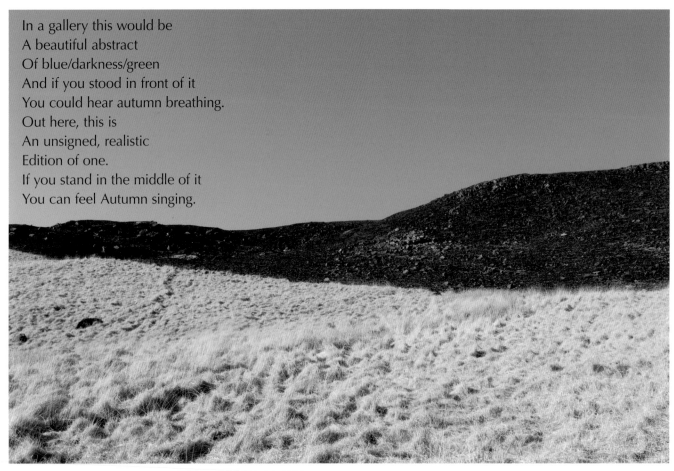

In a gallery this would be
A beautiful abstract
Of blue/darkness/green
And if you stood in front of it
You could hear autumn breathing.
Out here, this is
An unsigned, realistic
Edition of one.
If you stand in the middle of it
You can feel Autumn singing.

Saddleworth Moor

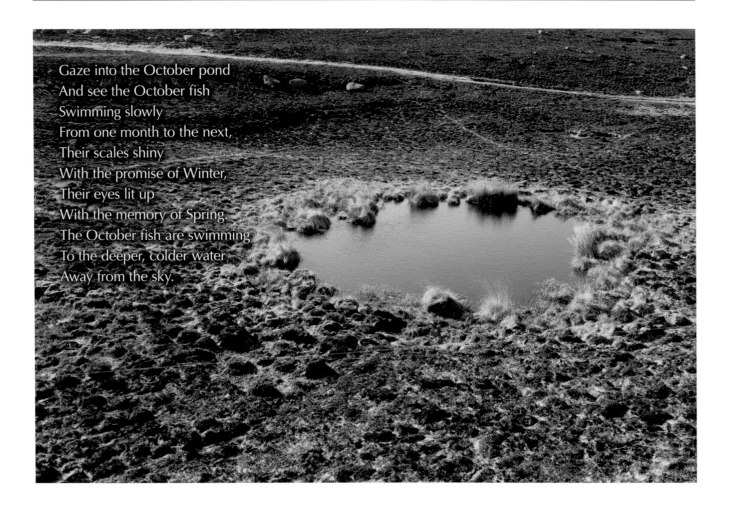

Gaze into the October pond
And see the October fish
Swimming slowly
From one month to the next,
Their scales shiny
With the promise of Winter,
Their eyes lit up
With the memory of Spring.
The October fish are swimming
To the deeper, colder water
Away from the sky.

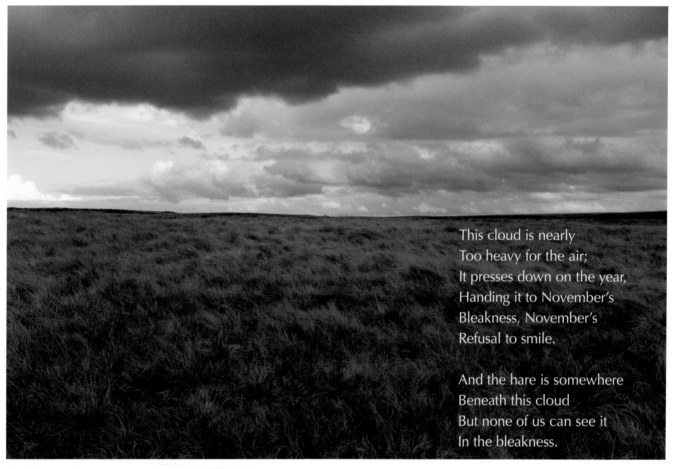

This cloud is nearly
Too heavy for the air;
It presses down on the year,
Handing it to November's
Bleakness, November's
Refusal to smile.

And the hare is somewhere
Beneath this cloud
But none of us can see it
In the bleakness.

Saddleworth Moor

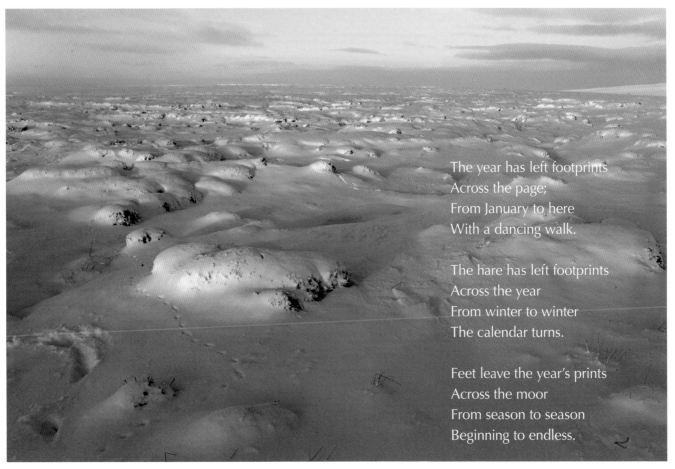

The year has left footprints
Across the page;
From January to here
With a dancing walk.

The hare has left footprints
Across the year
From winter to winter
The calendar turns.

Feet leave the year's prints
Across the moor
From season to season
Beginning to endless.

Saddleworth Moor

Striding the millstone grit

SLOW POEM ABOUT A SLOW PLACE

The millstone grit
The milestone grit.
Time and people
Slowly shaped this landscape

The heartstone grit
The hearthstone grit.
Time and people
Slowly shape this poem.

The millstone grit
The hillstone grit.
Time and people
Slowly shape this landscape.

The artstone grit
The art's tone grit
Time and people
Slowly shaped this poem.

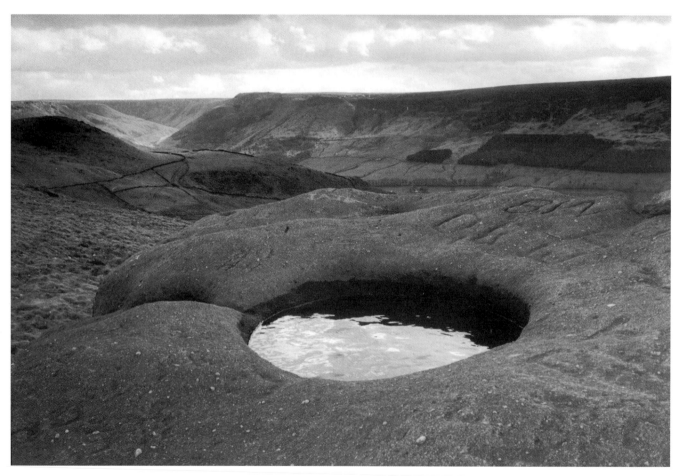

Millstone grit, pots & pans Saddleworth

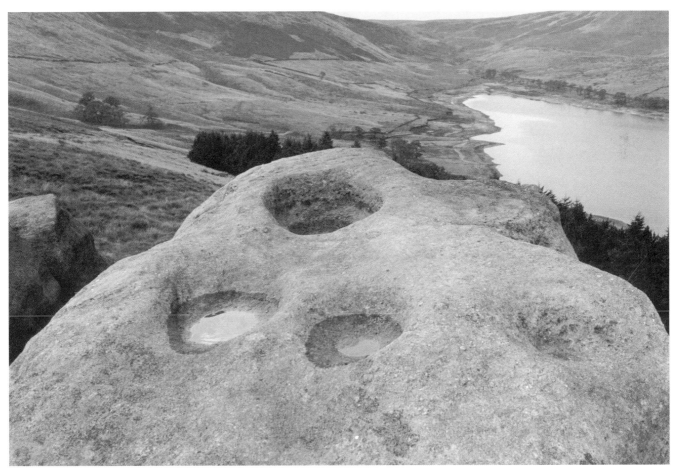

Millstone grit above Widdop reservoir

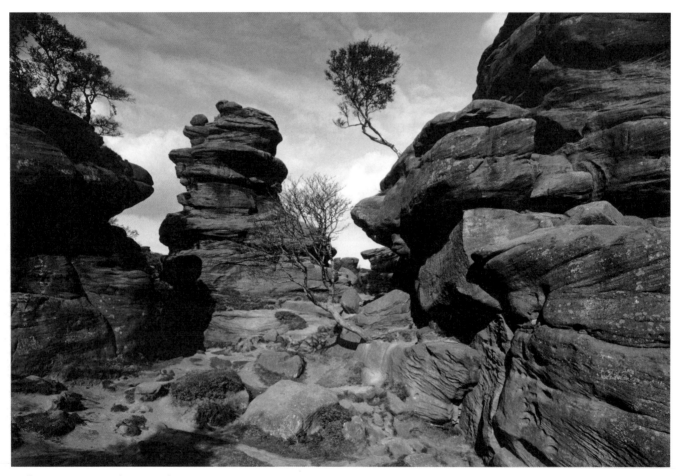

Millstone grit Brimham rocks

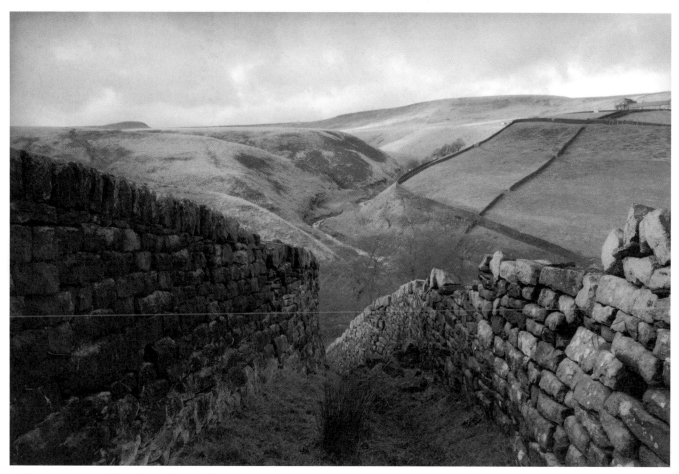

Millstone grit walls. The Colne valley.

Striding through York

EACH WALK IS A
GHOST WALK

York. Broad daylight, sunlight
Reflected from rising river-water
Into your shaded eyes. Ghosts

In daylight narrowed by old walls
Glance into the evening as I walk by:
Vikings, merchants, a boy running

From the past with a stolen apple,
A woman carrying folded cleaning
For the people in the big house.

I look, listen, make notes
In the day's bulging notebook:
Each walk in York is a ghost walk.

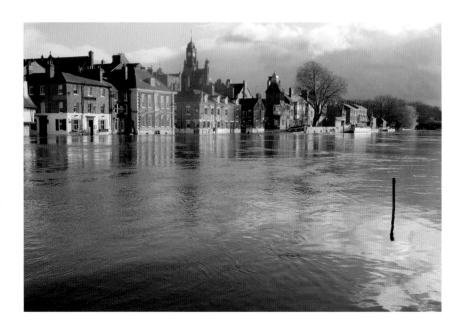

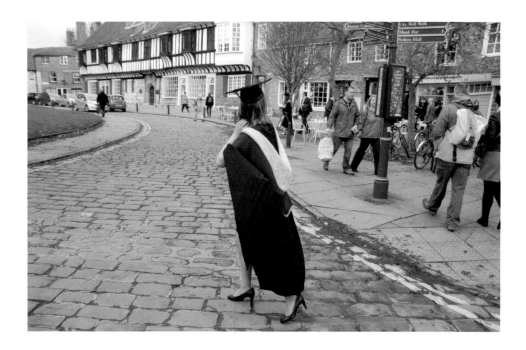

THE NEW HEELS, THE OLD STONES

The new heels, the old stones.
Sat in my room on that first night
The new light, the old sun.
And looked through the window
The new day, the old York.

And never thought I would see this:
The new smile, the old tears.
The learning rolled in my hand,
Carried through the streets
To a Yorkshire tomorrow.

HOW YORK THINKS

Lean your head to a York wall
And listen to the city think.

York thinks slowly, takes its time
Over each deliberation, builds
An idea from prehistory, through
History into memory, along
Shambles and railway line,
Riverside and Minster aisle,
Season built on season, year
Built on year. Listen, listen.

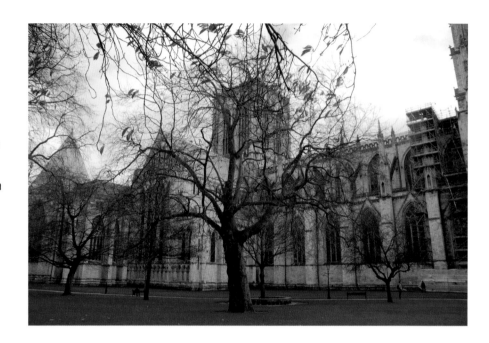

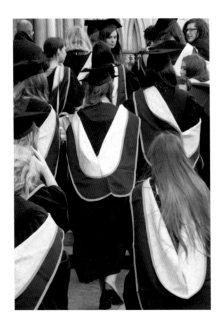

YORK THE YORK

Walk the York

Talk the York

Walk the Yark

Talk the Yark

Tark the Yark

Tark t'Yark

TarktYark.

A Bradford striding

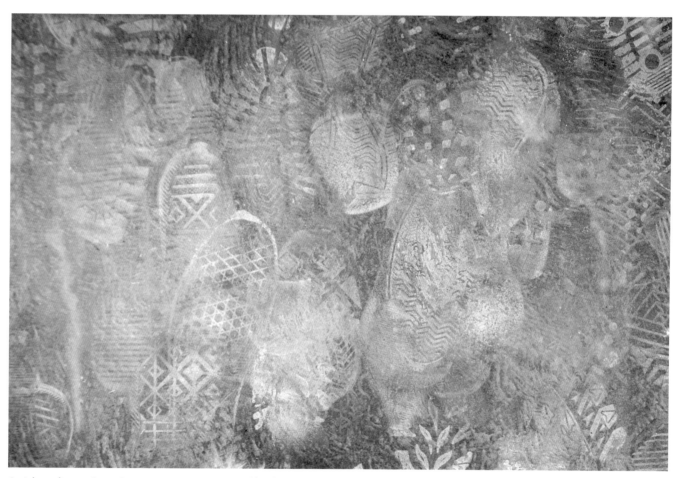

Striders footprints Centenary Square Bradford

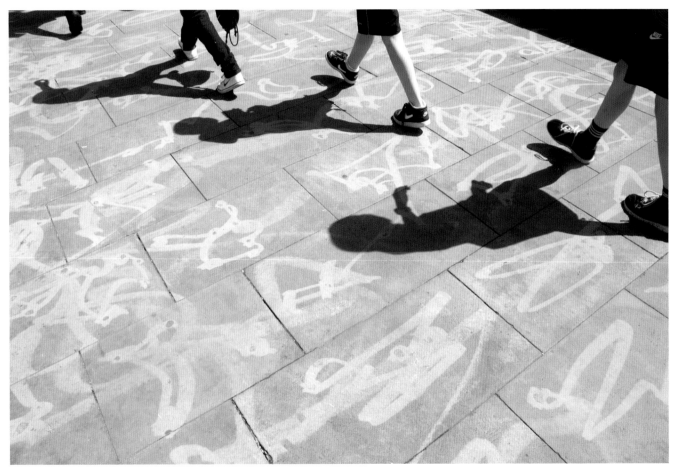

Striders Centenary Square Bradford

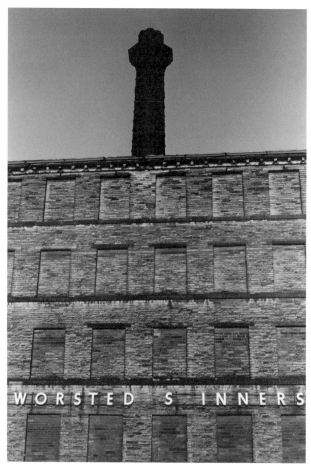

Illingworth's mill Bradford

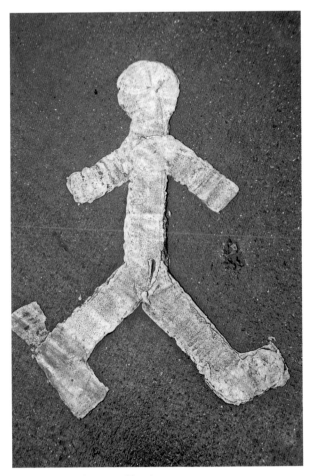

Painted strider Bradford

These ghostly walkers
Still lift their feet
And put them down
In a rhythm that never
 dies

Ghost walkers:
No pounding sound
Of feet. Just silence.
And movement
Always movement.

Walking
Is thinking
On your feet

Walking
Is laughing
On the way

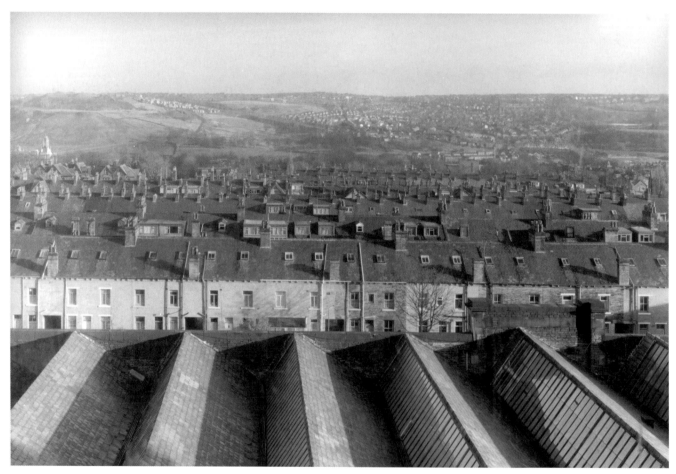

Weaving shed and terraced housing view from Listers Mill

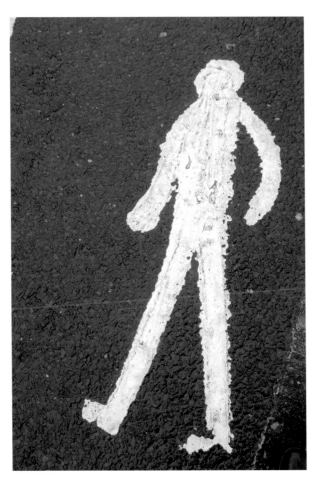

Painted striders Bradford

STRIDING

Evening striding is the best. Pass the cricket club and see a ball bowled, a catch taken.
Pass the chip shop and see a man in a white trilby stand with his arms folded, waiting
for the moment of perfection.
Pass the kids on the bench tapping into the world.
Pass a lost dog sniffing for memories.
Pass the bus that then passes you.

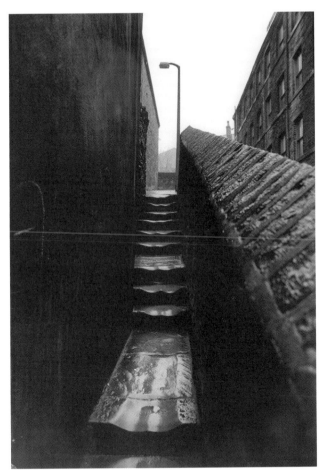

The snicket Bradford

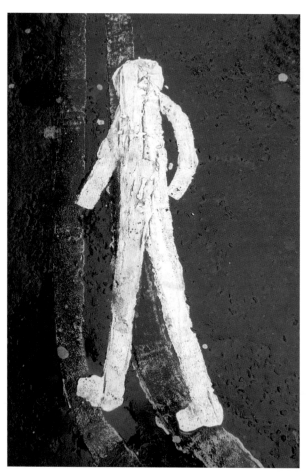 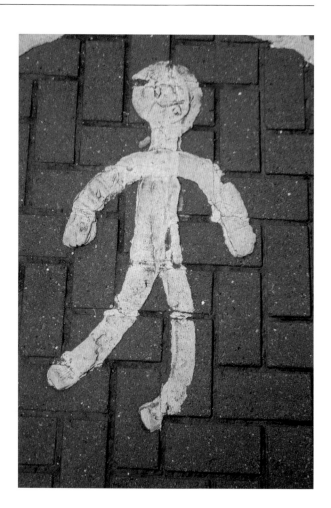

Painted striders Bradford

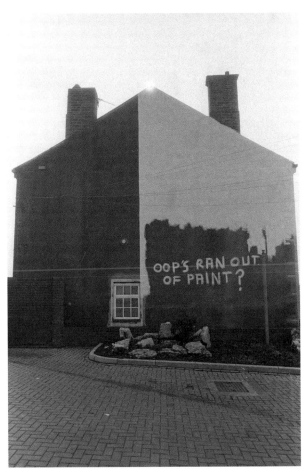

Gable end Bradford

Striding Swaledale

STRIDING

A long walk across a landscape that remembers the footsteps of those who strode over it before; a surprise of birds hovering then swooping away faster than you can count them. The ghosts of the mill girls and pitmen who walked this way in the clenched mornings and exhausted evenings. A light that you can't define, but which seems to arrive, just on time, from the day before yesterday.

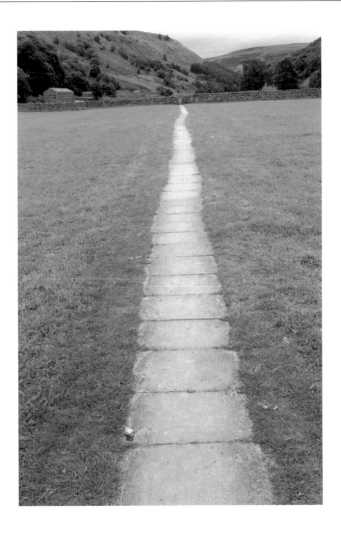

Swaledale

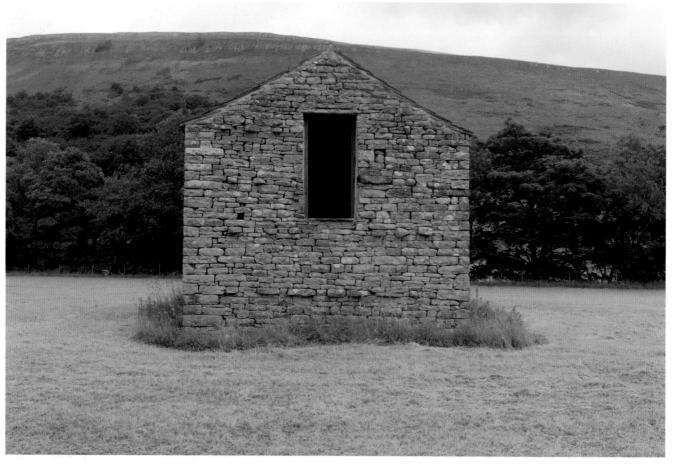

Swaledale

STRIDING

To the great force of Trudge I make obeisance in the rain. To the unseen pull of mud I sing songs that float to my cap's soaking neb. To the hovering presence of Stroll I put one foot in front of the other, again and again. To the choreographer of Stride I present the dance of the boots that never ends, that tightens the laces and clarts slap-dab in the treads, slap-dab and worse.

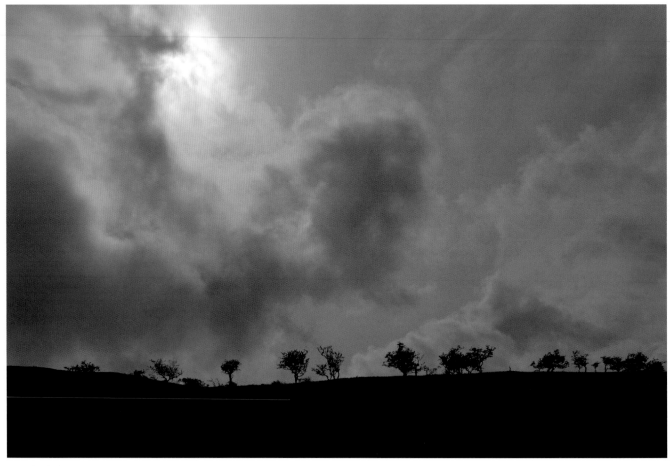

Swaledale

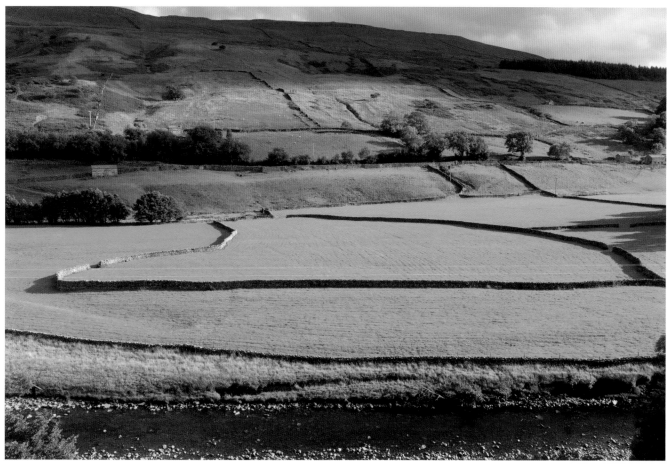

Swaledale

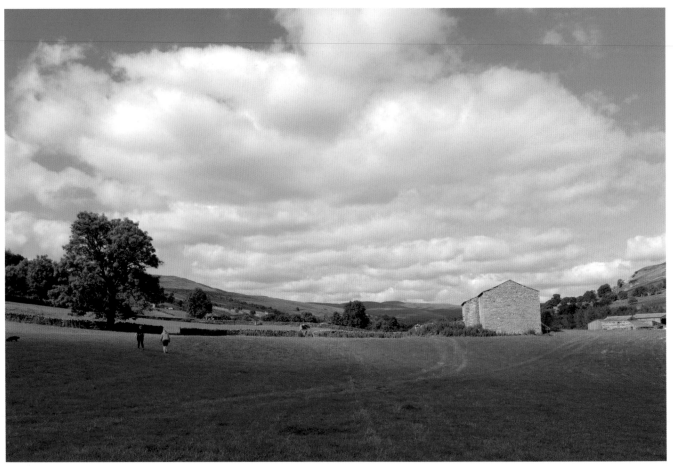

Swaledale

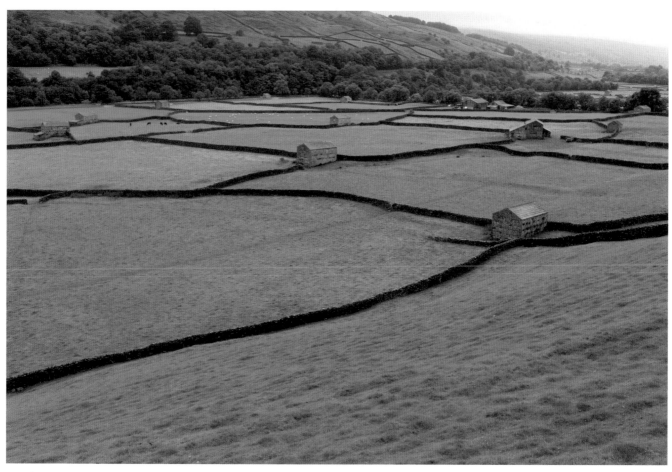

Swaledale

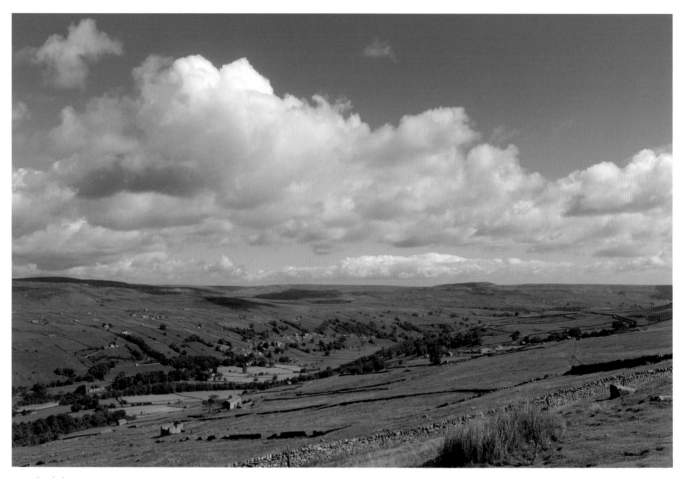

Swaledale

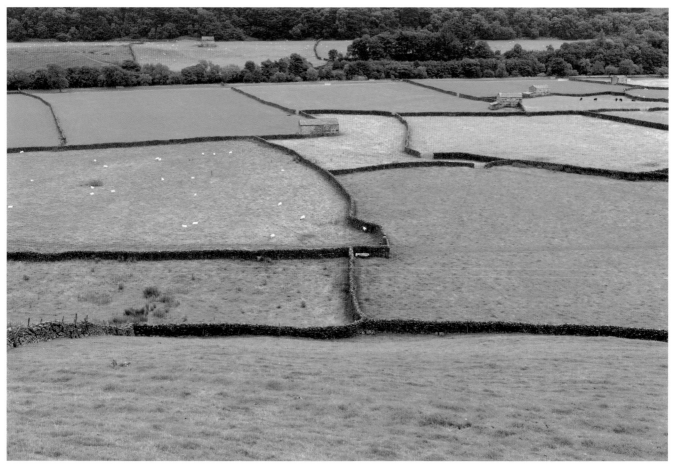

Swaledale

Swaledale

Striding the Yorkshire coalfields
above and below ground

Early morning striding is the best.

Down the darkened path past the spread of ideas and consequences that a street-light consists of.

Past milk bottles gleaming on steps: full, empty.

Past the kitchen and the man filling the kettle.

Down the hill to where the pit used to be, where the huge hoppers of coal crossed the road on wires, where the Pit Bus passed, spraying mud and dust.

An ancient settee waits in a garden and mist enjoys a half-life in the valley.

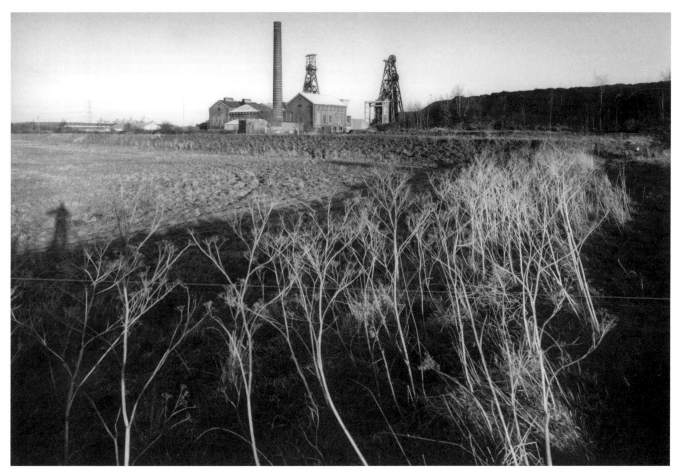

Rossington Colliery

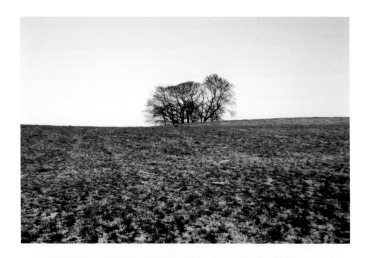

DRIFTED

Stand here and listen. Earth shifts,
Slightly, as though a butterfly
Has landed on a leaf's shadow
Mistaking it for a leaf.

Men worked under here. Beneath this.
History has drifted this mine away
Like water washes away that pattern of shells.

The ground lifts momentarily
Then sinks again. The movement
Is so small as to be
Almost no movement at all.

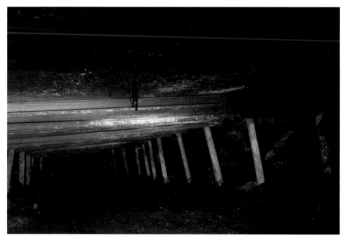

PIT SONNET: TREES

An underground forest is where I'm walking
Crouched down, bent over, a question mark;
There's a murmur somewhere the faint side of
 talking
And shadows of branches hang low in the dark.
Trees made this coal. A swamp where I squat,
A fossilized leaf is caught in my light.
I'm further in forest. I'm sweating, red hot.
And the air is ancient, squeezed and tight.
This walk through the forest is taking me back
To a time when the forest is all you could see
I click off my light and the hard wood turns
 black
And I can't see the coal for the tree.
Each time I light the fire, history starts to burn.
Trees have much to teach. I have much to learn.

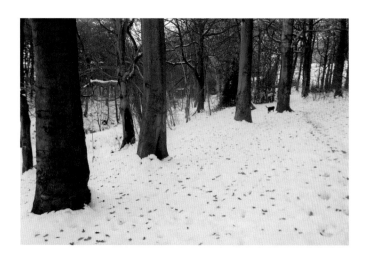

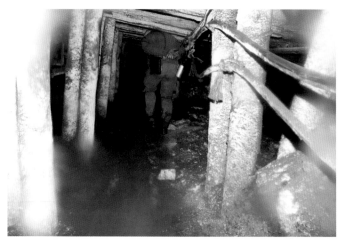

THE BACK, BENT

In the half-dark
The back, bent.
In the half-bent
Light, the back
Bends, half-aware
Of the dull pain
Of repetition, history.

In the half-light
The back, bending
In the half-awake
Light, the back
Bending, half-awash
With the harsh pain
Of history, memory.

In the half-gleam
The back glistens
With half-sweat,
Half-dirt; bends,
Listens for half-shifts
In the earth above;
Ear bent, rock-sweat.

Spring walk
Summer walk
Autumn walk
Winter walk
At a seasoned pace

The trees grow
As we walk
As we grow
As we walk
By the trees

YORKSHIRE ELEMENTS

WATER

Soaks you, Yorkshire does.
Drizzle like a dripping tap
Or a downpour wetting you through.
And that word *water*
Doesn't seem wet enough:
Try *watter.*
Watter: that's better. That's wetter.
Wet watter.

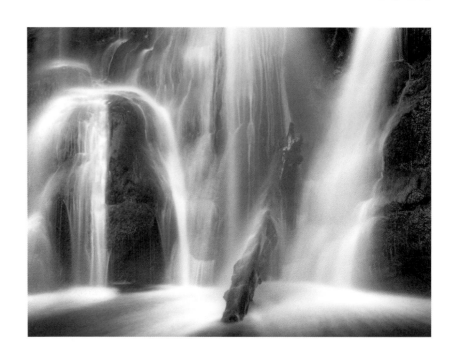

STONE

Feel it, under your shoes.
See it, in the buildings that seem to say:
We're here. We're Yorkshire. We're stone.
As you walk on the paths and the pavement
It waits, underneath, solid, ancient, older
than any words you might use to describe it
except by heck, by gum, by stooan.

FIRE

Fire on the moors and the smoke
Waves like Auntie Nelly's old scarf did
That time she ran to tell us
There was a fire engine coming.

Fire on the moors and the flames,
If they had voices, would sound like her,
Urgent, burning, Yorkshire:
Can't tha hear't tingalarie?

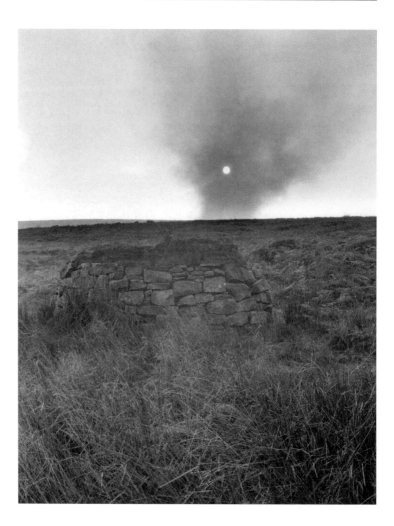

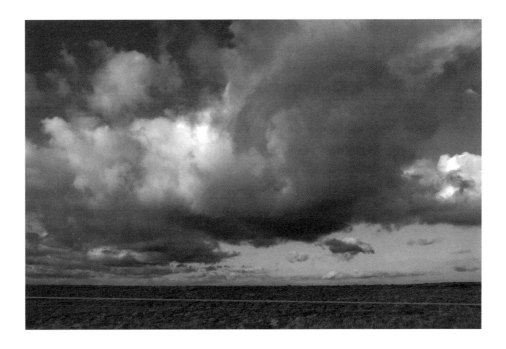

AIR

Up here in the Dales, there's plenty of it.
Air, everywhere you look. Air.
Or 8 for breeathin wi. Mornings, it's sweetest.
 Just a few birds have flapped through it. Air:
 Or 8 for singin' wi.

 Fill your lungs with it, then
 Run with it back to your house.

WEATHER

All the elements at once, here:
Water spraying your face,
Air speeding over your hands
Sun bursting through for a second,
Burning, briefly burning,
Then hiding behind the clouds
solid as rock, grey as stone:
Ivry seeason i'wun day.

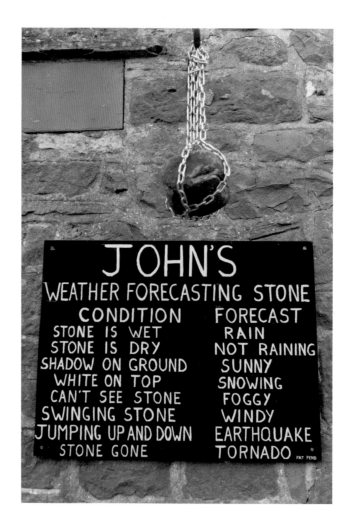

THE TEN BEST STRIDES

The stride you almost didn't take but at the last minute your boots called you and you answered.

The stride that began in despair and ended in Tong.

The stride that went to places on the map's fold or by the atlas's staple.

The stride that seemed to walk itself.

The stride that seemed circular but ended up being square.

The stride that took you to the very edge of Lancashire and then hesitated and turned back.

The stride where you sang all the way.

The stride that made itself up as it went along.

The stride that began in winter and ended in a kind of hesitant spring.

The stride that made you want to stride again and again.